INTRODUCT

The object of the books in the Famous Regiments Se
of both cigarette and trade cards that are availab..
Corps of the British Army. It must be borne in mind that the vast majority of these cards
were issued after the amalgamations of 1881, but before those of recent years, such as
'Options for Change'. By their nature and size they were extremely suitable for showing
individuals, such as Victoria Cross winners, leading generals and other prominent
personalities. They also show the full dress of the period making them very attractive
and collectable. Indeed cards issued at or before the Boer War can in some instances be
very difficult to find and valuable, whereas those produced just before the Second World
War are more readily available and less expensive.

The Cartophilic of Society of Great Britain, the name of the organisation for collectors
of such cards and formed in 1938, has produced a number of reference books over the
years, which are of invaluable assistance in identifying the numerous sets issued in just
over a century of the hobby.

This particular book, the first in the series, is of the Gordon Highlanders, and shows very
clearly the full colour splendour of the uniforms. badges and Regimental Colours of the
Regiment, as well as the very many interesting personalities who served in it, including
eleven of the Victoria Cross winners. Although not actually part of the Regiment, I have
included a section of the book to the London Scottish, who were attached to the Gordon
Highlanders for certain periods in their history.

Whether a collector of cigarette cards or not, I hope that the book will be of interest to
all readers.

David J. Hunter

Produced & Published by
David J. Hunter
11 Sunnindale Drive
Tollerton
Nottingham NG12 4ES

1998

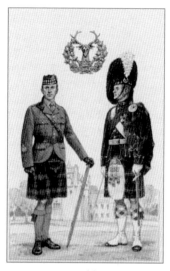

Issued by
The Army Careers Information Office
1991

Printed by
Adlard Print & Reprographics,
Ruddington
Nottingham

ISBN 0 9533738 0 0

Corrections to the Gordon Highlanders

Page 3 Second Para

1898 should read 1798
1899 should read 1799

Page 30 Line 8 after 1939, should read

when as an expanded Regiment of 3 battalions,
the 3rd Battalion became an artillery unit.

HISTORY OF THE GORDON HIGHLANDERS

The Gordon Highlanders were formed in 1881 by the amalgamation of the 75th (Stirlingshire) Regiment of Foot and the 92nd (Gordon Highlanders) Regiment of Foot, which became the 1st and 2nd battalions of the new regiment. The 75th (Highland) Regiment of Foot was raised in 1787 by Colonel Robert Abercromby, the brother of Sir Ralph Abercromby, for service in India. It fought in the 3rd and 4th Mysore Wars and won the right to bear the 'Royal Tiger' superscribed 'India' on the Regimental Colours. They returned to Britain in 1807. Two years later, along with a number of other highland regiments, they lost their highland status and reverted to being a line regiment. In 1834 they went to South Africa and fought in the operations against the Kaffirs. After a short spell back home they were sent to India in 1849 and were still there at the outbreak of the Indian Mutiny in 1857, when they marched 48 miles in only 38 hours in order to reach the field force headquarters at Umballa. They later saw action at Delhi where three members of the Regiment won the Victoria Cross. They returned home in 1862 and were re-named the 75th (Stirlingshire) Regiment of Foot, the title they retained until 1881, when they regained their highland status and resumed wearing highland uniform in June 1882, for the first time since 1809.

The 2nd battalion of the Gordon Highlanders was raised in 1794 by the Duke of Gordon as the 100th Regiment of Foot, being re-numbered the 92nd (Highland) Regiment of Foot in 1898. However it was known as 'The Gordon Highlanders'. Raising of sufficient numbers of recruits proved to be difficult and the Duke was then assisted by his wife, the Duchess of Gordon, who, as legend states, went around the country fairs in a highland bonnet and regimental jacket offering a kiss to any man who enlisted. Whatever the truth of the story, the Regiment was raised and first saw action in 1899 during the campaign in Holland, followed by the expedition in Egypt the next year. It was during the battles in the latter that the Regiment won the right to wear the badge 'Sphinx' superscribed 'Egypt'. They took part in the historic retreat to Corunna, and in commemoration of the defence and the death of Sir John Moore, they wear black threads in their shoulder cords and black buttons on their spats. They fought in Spain in the various battles under the Duke of Wellington, eventually crossing into southern France, when a peace treaty was

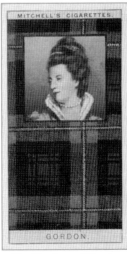

The Duchess of Gordon
from Clan Tartans
issued by Stephen Mitchell

signed and the Regiment returned home. However when Napoleon returned from Elba the 'Gordon Highlanders' were again in action during the 100 days campaign, which resulted in the Battles of Quatre Bra and Waterloo.

It was during the Battle of Waterloo that the 'Gordon Highlanders' took part in the epic and well known engagement, where a number of the soldiers clinged to the stirrups of the Royal Scots Greys as they charged the French. During the battle the 92nd lost 14 killed and 102 wounded. After Waterloo the Regiment saw virtually no action for 64 years, missing both the Crimean War and the Indian Mutiny, although it served in Gibraltar, Jamaica, Ireland and India, as well as in their home, Scotland. However this changed in 1879 when they took part in the Afghan War and the march to Kabul. It was during this campaign that Lieutenant Dick-Cunyngham won his Victoria Cross, as did Major George White on the recommendation of the force commander, Lord Roberts. No sooner had this engagement come to an end when they were sent to the Transvaal where a small detatchment took part in the disasterous action at Majuba against the Boers in 1881. Nevertheless they fought bravely and suffered casualties of ninety-six officers and men out of 118 engaged. Two officers, Lieutenants Ian Hamilton and Hector MacDonald, distinguished themselves particularly, both of whom appear on cigarette cards later in the book.

Although both the 75th and 92nd would have preferred to remain distinct regiments, they accepted the amalgamation, and quite unusually retained the name of the junior of the two regiments, presumably in recognition of its very distinguished record. Almost as soon as it had become re-titled the 1st battalion was sent to the Sudan and took part in the Battle of Tel-El-Kebir and joined the column to relieve General Gordon, whereas the 2nd battalion returned to India and saw action on the NW Frontier. Here Piper George Findlater won his V.C. With the start of the Second Boer War both battalions saw distinguised service in South Africa, the 1st with the Highland Brigade at Magerfontein and the 2nd as part of the beseiged force at Ladysmith.

In 1914 the 1st battalion was one of the first to go to France and took part in the famous retreat from Mons, although most of them were captured after fierce fighting near Clary, while the 2nd later took part in the Italian campaign. During the First World War the Regiment raised a total of 21 battalions. With the outbreak of the Second World War in 1939 the 1st battalion was again one of the first to go to France and joined the 51st Highland Division in March 1940, although once again it was forced to surrender, this time as part of the rear guard for the troops at Dunkirk. The 2nd battalion was equally unlucky surrendering to the Japanese in Singapore. Both battalions were reconstituted, the 1st from a nucleus of soldiers at the Depot in Aberdeen, and the 2nd from the 11th battalion. The reconstituted 2nd battalion took part in the Normandy landings in 1944, while the 1st battalion took part in the landings in Italy and later also took part in the Normandy landings. Other battalions took part in the Desert campaign, including the Battle of El Alamein, Italy, India and Burma. In July 1948, in common with all line infantry regiments, the Regiment was reduced in strength with the 2nd battalion being absorbed into the 1st, thereby being a single battalion regiment again.

They were finally amalgamated with the Queens Own Highlanders in September 1994 to form The Highlanders (Seaforth, Gordons and Camerons).

HISTORY OF CIGARETTE CARDS

With the advent of cigarette wrapping machines in the late 19th Century plain pieces of card were used as 'stiffeners' for cigarette packets, bearing mind that these were flimsy paper packages unlike the card boxes of today. By the late 1870s the tobacco manufacturers in the USA. started embellishing these card inserts with advertisements and pictures. Smokers soon started collecting these cards in order to obtain full sets of the different series and the hobby of Cartophily was born.

By the 1890s many of the larger British tobacco companies were also issuing similar cards. Like in the USA. they began with advertisements and soon progressed to various series of a particular themes (e.g. beauties, soldiers, ships, Kings & Queens, etc.) The early cigarette cards were produced on thick board and of an exceptionally high quality of coloured lithographs, although when card packets were introduced in the 20th Century they became much thinner. The first company to introduce photographic cards on a large scale was Ogdens of Liverpool, initially with actresses, and later with generals and other prominent personalities of the Boer War which was raging at the time in South Africa.

It was Ogdens which was to become the springboard for an American assault on the British tobacco market. It must be borne in mind that at the turn of the century there were dozens of cigarette manufacturers, whereas today there are only a few very large ones. In 1901 James 'Buck' Duke, President of the giant American Tobacco Company, bought Ogdens of Liverpool and set about a programme of price cutting and bonus schemes with the purpose of swallowing up the British companies one by one. However thirteen of the largest UK. manufacturers, including W.D. & H.O. Wills of Bristol and John Player & Sons of Nottingham, pooled their resources to meet the challenge and formed the Imperial Tobacco Company. They then fought back and were so successful that they even opened a factory in the United States hitting Big Duke on his home territory. As a result a truce was made and the American Tobacco Company agreed to withdraw from the UK. and Imperial Tobacco agreed to do the same in the USA. Ogdens was then sold to the Imperial Tobacco Company. In order to deal with the export business of both companies outside the USA. and the UK., the British American Tobacco Company was formed, based in Britain, with the shares and Board of Directors controlled by both companies. However Big Duke ended up the loser as when American Anti-trust laws came into force, the American Tobacco Company was broken up, as is was deemed to be a monopoly. The British American Tobacco Company (B.A.T.) eventually became a huge concern with factories all over the world.

In the early 1900s there were around 150 different tobacco companies in the UK., each issuing cards, and by 1919 approx. 1800 sets had been issued. Each of the Imperial Tobacco Companies (e.g. Wills. Lambert & Butler, Players Ogdens, etc.) issued their own series, although eventually they were all produced and printed by Marsdons.

MILITARY CARDS

As with post cards, the Boer War stimulated a large interest in military subjects. Although W.D. & H.O. Wills had issued Soldiers & Sailors in 1894 and Soldiers of the World the following year, these cards were not just of British Regiments but from across the world. The first all British set of military uniforms was in 1898 when Gallaher Ltd., a firm based in Belfast, issued their Types of the British Army. It consisted of 100 subjects, including leading generals, mostly painted by Harry Payne, a well known military artist who was also a corporal in the West Kent Yeomanry. It was unfortunate that not every regiment is illustrated, but nevertheless a superb set. Another example of early excellence was a set of 25 Types of Volunteer and Yeomanry issued in 1902 by W.H. & J. Woods Ltd., based in Preston. During the Boer War there were many sets produced of generals and other prominent personalities, and indeed many manufacturers used the same photographs. The Transvaal Series by W.D. & H.O. Wills is a good example of cards with the same photograph, but with different brands advertised on the back and different captions on the front to illustrate changes in rank or the fact that they had been killed, (e.g. Baden-Powell as a Colonel, Major-General and Lieutenant-General). Not surprisingly Victoria Cross winners received much attention back home and between 1901 and 1904 James Taddy & Co. produced a superb series of 125 Victoria Cross Heroes which was issued in 5 sets of 20 and one of 25 cards. They were of excellent quality, some of which are now very rare.

Indeed James Taddy & Co., which was a small firm based in the east end of London, produced a very large number of high quality military sets from the Boer War to the start of the First World War, such as Medals & Ribbons, Boer War Leaders, Admirals & Generals and Territorial Regiments, etc., all of which are well sought after. W.D. & H.O. Wills also produced a number of military sets, although most of them were only issued overseas. One interesting set was Types of the British Army, a set of 50 uniforms of the British Army that it was issued throughout the Empire, but with different brands advertised on the backs of the cards depending on the country in which they were sold. In addition, as is shown later in the book, it was also issued by other manufacturers, making the collection of the different backs very interesting. Almost every military theme was covered by different sets, such as Medals, Regimental Standards & Colours, Uniforms, Badges, Buttons, Generals and Victoria Cross Winners, etc.

The start of the First World War brought about the issue of a number of patriotic sets, such as Britain's Defenders, which was issued throughout the Empire, and a set of 12 Recruiting Posters, both of which were issued by W.D. & H.O. Wills. Gallaher Ltd. issued their Great War Series in two sets of 100, and their well sought after series of 200 Victoria Cross Heroes, which was issued in eight sets of 25. W.D. & H.O. Wills also issued a set of 50 Military Motors in 1916, followed by Allied Army Leaders in 1917.

Although the war brought about the production of a number of sets, it also stopped the issue of one titled Waterloo. Indeed some had already been printed, but with the start of

the war it was felt inappropriate to have a set of cards which could be seen as anti French at a time when they were now one of Britain's Allies. The set was then scrapped, although a few survived and are now extremely rare and valuable.

During the war a number of silks were issued in packets of cigarettes by some manufacturers, the leading one being Godfrey Phillips Ltd. Many of these were of a military theme, such as Crests & Badges of the British Army. It was a set of 108 and was also issued by other firms. However silk issues of Regimental Colours were particularly attractive with the silk background making them look very realistic. Regimental Colours by B. Morris & Sons Ltd. and a number of similar sets by Godfrey Phillips in different sizes, some of which are illustrated in this book, are particularly attractive.

With the end of the First World War there was an understandable lack of interest in military subjects and it wasn't until 1924 that John Player & Sons issued a set of 150 Army, Corps & Divisional Signs, followed by a similar set of 50 from B. Morris & Sons Ltd. They were an instant success as former soldiers could relate to their former Divisional or other Formation Signs. John Player & Sons also issued a set of 90 War Decorations & Medals in 1929, which not only had British medals, but ones from every country that fought on the allied side, including Japan. These were followed by many other sets, once again covering the full range of military topics, including another nice set from John Player & Sons titled Military Head-Dress. Although by the 1930s great care was taken in the accuracy of the detail, Godfrey Phillips made an error in their set of Soldiers of the King, when they showed the Welsh Guards with a goat mascot. The artist was clearly mixed up with the Welsh Regiment and the card was repainted.

However it was in the late 1930s with the possibly of another war, that there was a flood of military sets from the different manufacturers. In 1938 John Player & Sons, issued a set of Military Uniforms of the British Empire Overseas, followed by a set of Uniforms of the Territorial Army in 1939. Both sets were on thin card and had gummed backs in order that they could be stuck into specially produced albums. All of the major manufacturers issued at least one military set in this period, such Air Raid Precautions by W.D. & H.O. Wills, Modern Armaments by Louis Gerrard Ltd., Britains Defences by Carreras Ltd., Life in the Services by the Ardath Tobacco Co. Ltd and Army Badges by Gallaher Ltd. It is interesting to note that Air Raid Precautions was the largest run of any cigarette card set and was also issued by many other Imperial Tobacco companies. By 1940 there was a shortage of paper and cigarette cards ceased to be issued. After the Second World War a few of the smaller firms started producing cigarette cards, but not of a military nature nor of the same quality as before. It should be noted that Marsdons of Bristol, which was a firm of printers owned by Imperial Tobacco, producing the cards for their companies in the 1930s , was destroyed in an air raid during the war. They were a firm who took their work very seriously and who employed a team of artists who researched and specialised in different subjects, such as military uniforms.

However in the 1970s a number of sets had been produced by some of the Imperial Tobacco companies, one of which was Decorations & Medals by John Player & Sons, and in the same

format as the set War Decorations & Medals issued in 1929. Although for number of marketing reasons none of these sets were never issued, many 'leaked out' from the printers, some of which aren't took difficult to obtain. John Player & Sons started issuing sets of cards with some of their cigar brands in the late 1970s, one of which was History of the V.C., a set of 24. Unfortunately they have now ceased marketing the brands concerned. However at about the same time the Wills Castella band of cigars started issuing sets of cigar cards, and although there has only been one military set, it was a superb one titled Waterloo in 1995.

The Amalgamated Tobacco Corporation, makers of Mills filter tips, issued a few military sets between 1959 and 1961, such as Army Badges - Past & Present which includes a number of the Army Corps formed during the war illustrated (e.g. The Intelligence Corps). It also issued British Uniforms of the 19th Century, which consisted of 25 uniforms of infantry regiments, and which was also copied by a number of Trade firms, such as United Dairies.

TRADE

Although for practical purposes cigarette cards ceased to be issued shortly after the start of the Second World War, there was still a public demand for them, and a result a number of Trade sets were produced, mainly from tea producers, although unfortunately few of them were of a military theme.

Before the WW2 a number of trade issues had been produced, such War Portraits by a the Elite Picture House and V.C. Heroes by Alex Ferguson, which were mainly the same as those issued by the cigarette manufacturers, and therefore of the same high quality. However the Home & Colonial Stores produced a number of attractive military sets of their own in 1916 (e.g. War Heroes and two sets of War Pictures).

Unfortunately the quality of the post 1945 issues isn't as good, but they are still very collectable. A number of firms issued British Cavalry uniforms of the 19th Century and British Uniforms of the 19th Century, both sets of 25 cards. Tommy Gun Toys issued a set of 50 Medals in 1971, which is particularly interesting as it has some of the medals awarded in the Second World War . One of the best sets was one titled British War Leaders, issued in 1949 by Joseph Lingford & Sons, makers of Baking Powder. It was of the pre-war quality and consisted of 36 subjects, including Army, Navy, Air Force and political leaders such as Montgomery, Alexander and Churchill. A number of these cards are illustrated later in the book.

In recent years a number of the harder to obtain cigarette cards sets have been reproduced, with military subjects in their full colour uniforms being particularly popular. Also the sets of the series of 125 Victoria Cross Heroes, that were issued by James Taddy & Co. are now available for collectors for a only few pounds.

These are from two of the earlier sets. Soldiers of the World was originally a set of 100, increased to 101, but later printings with revised artwork reduced the set to 75. Home & Colonial Regiments was a set of 40 cards and was issued by various smaller manufacturers, some of which are quite rare. Cohen Weenen & Co. issued the set with a 100 and 250 back, and also with a gold border, although this is extremely rare.

Issued by
W.D. & H.O. Wills in 1895

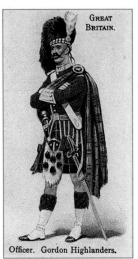

Soldiers of the World
various printings world-wide

Issued by
B.A.T. in 1902

Issued by
R.P. Gloag & Co. 1900

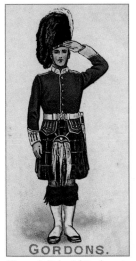

Home & Colonial Regiments
issued by 8 firms

Issued by Cohen Weenen
with different backs in 1901

The first examples are from the Gallaher set of Types of the British Army which was first issued as a set of 50 cards with a Battles Honours back in 1897. It was reprinted the following year with a green back as shown and later as a set of 100 with two different brown backs. The subjects were painted by Harry Payne, the well known military artist, who painted very many cigarette cards and post cards during this period.

The Three Pipe Tobaccos

MILD

GALLAHER'S

GOLD PLATE HONEY DEW

MEDIUM

GALLAHER'S TWO FLAKES

FULL

GALLAHER'S

RICH DARK HONEY DEW

All in 1, 2 & 4 oz. Tins.
Secured by Patent Band.

Issued with
Green and Brown backs

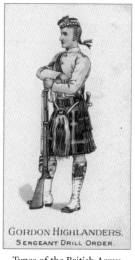

GORDON HIGHLANDERS.
SERGEANT DRILL ORDER.

Types of the British Army
issued by Gallaher Ltd. 1898

Now in Three
Strengths,
MILD, MEDIUM & FULL.

GALLAHER'S

TWO FLAKES

TOBACCO.

In 1, 2 & 4 oz. Tins
Secured by Patent Band

GALLAHER Lᵗᴰ

Issued with Brown back

The set of Military Head-Dress was issued by John Player & Sons in 1931 with each of the cards superbly researched and painted. The Company, based in Nottingham, was one of the largest cigarette manufacturers in the UK and one of the original 13 firms who formed the Imperial Tobacco Company in 1901. It issued many military sets, most of which were produced and printed by Marsdons of Bristol, which was owned by Imperial Tobacco Ltd.

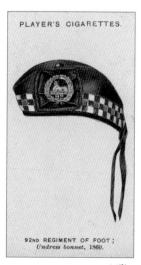

PLAYER'S CIGARETTES.

92ND REGIMENT OF FOOT;
Undress bonnet, 1860.

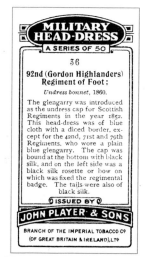

MILITARY
HEAD-DRESS
A SERIES OF 50

36

92nd (Gordon Highlanders)
Regiment of Foot:

Undress bonnet, 1860.

The glengarry was introduced as the undress cap for Scottish Regiments in the year 1852. This head-dress was of blue cloth with a diced border, except for the 42nd, 71st and 79th Regiments, who wore a plain blue glengarry. The cap was bound at the bottom with black silk, and on the left side was a black silk rosette or bow on which was fixed the regimental badge. The tails were also of black silk.

ISSUED BY

JOHN PLAYER & SONS

BRANCH OF THE IMPERIAL TOBACCO Cº
(OF GREAT BRITAIN & IRELAND), LTᴰ

Military Head-Dress
issued by John Player & Sons 1939

SILK REGIMENTAL BADGES

In addition to the silk issues of Regimental Colours, several tobacco manufacturers also produced a number of silk issues of Regimental Badges such as those shown below. The first is one of a set of 100 Regimental Crests & Badges from R.J. Lea issued in 1923 with the second by Singleton & Cole from a set of 110 Crests and Badges of the British Army issued in 1915. The next a similar set by the British American Tob. CO., followed by one from Godfrey Phillips. BAT also had a similar set in a smaller size. and one in paper as opposed to silk. Phillips produced several in different sizes and with printing varieties. Only the B.A.T. set has a title on it.

Regimental Crests & Badges
issued by R.J. Lea Ltd in 1923

Crests & Badges of the
British Army issued
by Singleton & Cole 1915

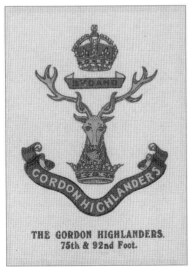

Crests & Badges of the British Army
issued by B.A.T. in 1915

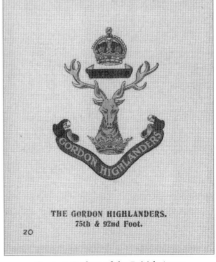

Crests & Badges of the British Army
issued by Godfrey Phillips in 1914

TYPES OF THE BRITISH ARMY

This was a particularly interesting set in that although it was issued in dozens of countries all over the world, it was never issued in the United Kingdom. It was issued with Scissors cigarettes from W.D. & H.O Wills in 1908, which were sold to British Garrisons overseas, mainly India. As it was only a set of 50 cards it is therefore surprising that there are 3 different illustrations of the Gordon Highlanders in the series.

Vice Regal Cigarettes
issued by Wills in 1912

Woodbine Cigarettes
titled British Army Uniforms

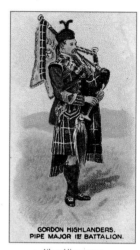

Flag Cigarettes
issued by Wills in 1912

Flag Cigarettes
issued in South Africa

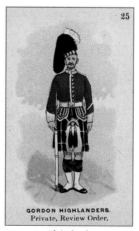

Plain back
issued by B.A.T. in China in
1908

Capstan Cigarettes
issued in Australia in 1912

TYPES OF THE BRITISH ARMY

Here we see some further examples of the backs of the various manufacturers and their country of origin. In addition both Capstan and Vice Regal cigarettes each had two different printings in which a different style of lettering was used for the description on the front. B.A.T. issued two plain back sets, one numbered and one unnumbered.

Issued in Siam in 1909

Pinhead Cigarettes
issued by B.A.T. in 1909

Issued in China in 1909
by The Alliance Tobacco Co.
Ltd

Scissors Cigarettes
issued in India & Garrisons

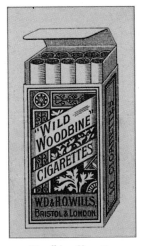

Woodbine Cigarettes
General Overseas issue 1909

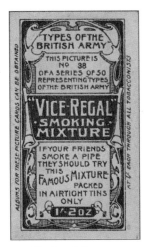

Vice Regal Cigarettes
issued in Australia in 1912

During the First World War the Gordon Highlanders raised a number of new battalions, in addition to the two Regular, the Reserve and Territorial Force ones, all of which were called up. Most of these battalions saw active service and were allocated to different divisions. On this page we some examples of the Divisional signs in which the different battalions served, most of which appeared in the John Player & Sons set of 150 Army, Corps and Divisional Signs, issued between 1924 and 1925. Others are from the set

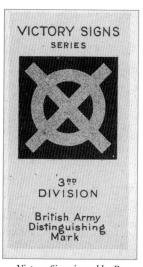

Victory Signs issued by B. Morris (Yellow on Black)

of 50 Victory Signs, issued by B. Morris & Sons in 1928. The 1st battalion was one of the first to land in France and spent almost the entire war with the 3rd Division, except for a short period following heavy losses at Le Cateau when they became Army Troops. The 2nd battalion was in Cairo at the start of the war, but sailed for England and on arrival was sent to 7th Division with which they then went to Belgium and later, in 1917, to Italy. The 1/6th (Banff and Donside) Bn was also attached to the 7th Division from December 1914 to June 1916. Following their amalgamation after heavy losses the 8th/10th Bn was attached to the 39th Division from June 1918, until it was disbanded in August. The only battalion to serve with the 67th Division was the 52nd (Graduated) Bn, formerly a training battalion of the Cameron Highlanders, which it did from October 1917 until November 1918. During this time it was stationed at Colchester.

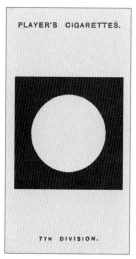

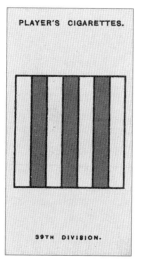

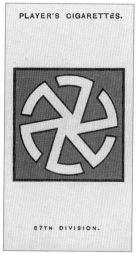

Army, Corps & Divisional Signs issued by John Player & Sons 1924-25

(White on Black) (Blue & White) (White on Grey)

Not surprisingly a number of battalions served with the 51st Highland Division, initially titled the Highland Division. With the exception of the period from February 1915 until February 1916 when it was with the 3rd Division, the 1/4th Bn spent the entire war with the 51st Division. The 1/5th (Buchan & Formartin) Bn also joined the Division in August 1914 and remained with it until February 1918 when it joined the 61st Division. There it remained until June 1918 when it was transferred to the 15th Division. The 1/6th (Banff & Donside) Bn joined the Division in August 1914 and stayed with it until November 1914, when it was sent to France and served with the 7th Division until June 1916, when it rejoined the 51st Highland Division. The 1/7th (Deeside Highland) Bn joined the Division in August 1914 and stayed with it until October 1918, when it was amalgamated with the 1/6th (Banff and Donside) Bn to form the 6th/7th Bn. The 8th (Service) Bn was formed in August, later joining the 9th (Scottish) Division, with which it stayed until May 1916 when it was sent to the 15th Division . It was then amalgamated with the 10th Bn, which had been serving with the Division since 1914, to form the 8th/10th Bn. It was reduced to a cadre in June 1918 and disbanded in August. The 9th (Service) Bn (Pioneers) was formed in September 1914 and spent the entire war with the 15th Division.

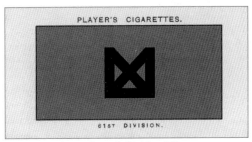

Army, Corps & Divisional Signs
issued by John Player & Sons 1924-25
(Black on Red)

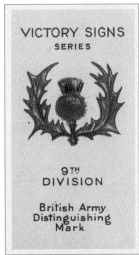

Victory Sign Series issued by B. Morris & Sons 1928

(Green & Purple) (Red in Black)

Army, Corps & Divisional
Signs (Black inside Red)

Here are illustrated some further interesting cards. The first is from the set of Regimental Collar Badges & Crests by Stephen Mitchell which was issued about 1900. It was the only set issued on collar badges and unlike most cigarette cards of the period, had some text on the reverse side. Stephen Mitchell was a small Scottish firm based in Glasgow which was established in 1723, becoming part of Imperial Tobacco Ltd., in 1901. The other two illustrations are 'Cut Outs' produced by Major Drapkin from Soldiers & Their Uniforms in 1914.

Regimental Collar Badges
Crests issued by
Stephen Mitchell 1900

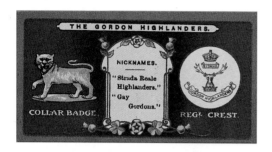

Major Drapkin was also a small tobacco firm, based in London which was founded in 1898 and taken over by Godfrey Phillips in 1931. Apart from these sets and Celebrities of the Great War in 1916, the only military sets it issued were silks ones on Regimental Colours & Badges of the Indian Army in 1915.

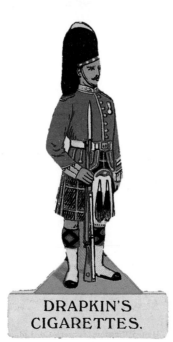

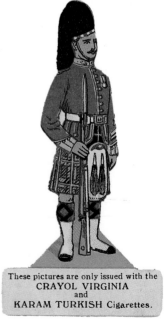

Soldiers & Their Unifomns
issued by Major Drapkin & Co. in 1914

In 1916 W.A. & A.C. Churchman, a branch of Imperial Tobacco based at Ipswich, issued a very attractive set of 25 Army Badges of Rank. Below are six examples showing officers badges of rank for Scottish regiments worn on khaki doublets until about 1917, when they were officially worn of the shoulder straps.

2nd Lieutenant

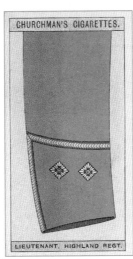

Lieutenant

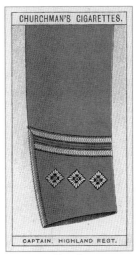

Captain

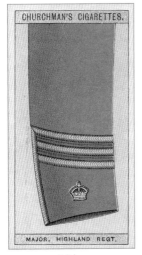

Major

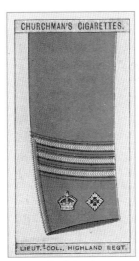

Lt-Colonel

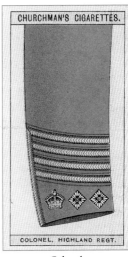

Colonel

The first three illustrations are from the set of Army Crests & Mottoes which was issued by Ogdens of Liverpool in 1902 and printed by Gale & Polden of Aldershot. Unusually it was a set of 192 with most regiments represented by more than one card as can be seen by the examples shown. It is also interesting to note that there are very many varieties and errors in this series due to many different printings, although to the best of my knowledge not with the Gordon Highlanders. Beauties & Military, also issued by Ogdens, was one of a set of 52 cards with a mixture of beauties and military subjects, each with a playing card insert. Finally a nice set from Walters Palm Toffee in 1938.

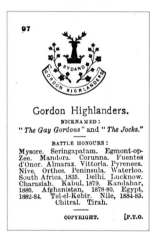

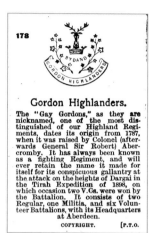

Army Crests & Mottoes
issued by Ogdens in 1902

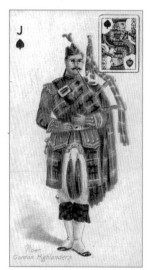

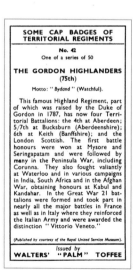

Beauties & Military
issued by Ogdens Ltd. 1898

Some Cap Badges of Territorial Regiments
issued by Walters Palm Toffee in 1938

TRADE

In addition to the cigarette and tobacco manufacturers there were also a number of Trade issuers such as tea producers. Illustrated are a few examples, together with their backs, which are equally interesting, especially with regards to the series British Uniforms of the 19th Century. The first is from a set of 25 of Badges & Uniforms of Famous British Regiments and Corps, which was issued by E.H. Booth & Co. Ltd, a tea producer. At the bottom of the page is Soldiers of the World which was originally issued in 1966 by Barratts Sweets. However it was later copied by Wiko in 1969, a firm based in Germany. It is unfortunate that the quality of the paintings is rather poor, but is typical of many modern trade sets.

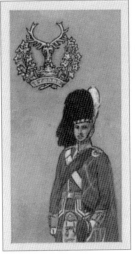

Badges & Uniforms of Famous British Regiments & Corps
issued by E.H. Booth & Co. Ltd. (Tea) in 1967

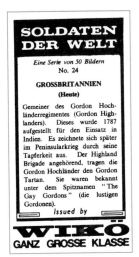

Issued by Wiko (Germany)
1969

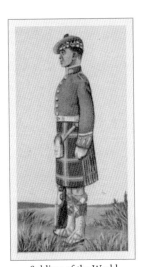

Soldiers of the World

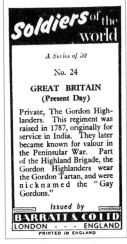

Issued by Barratts Sweets
1966

Here again we see examples of sets of cards that have been issued by more than one Trade firm. The first is Bandsmen of the British Army which was first issued by Sew & Sew in 1960, followed by The Universal Collector's Shop in Twickenham and an anonymous issue. Like most trade sets it comprised of 25 subjects, regrettably without captions, therefore it isn't possible to identify all of the regiments shown.

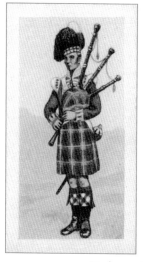

SEW & SEW
HABERDASHERY

TRIMMINGS
BUTTONS
LACE
BRAIDS
AND
ZIP FASTENERS

presented by
SEW & SEW
Croydon Surrey

Bandsmen of the British Army
issued by Sew & Sew 1960

British Uniforms
Issued by various firms

BRITISH UNIFORMS
a Series of 25)

No. 20
THE GORDON HIGHLANDERS
The 75th (Highland) Regiment of Foot, now the Gordon Highlanders, was founded by Robert Abercromby of Tullieby in 1787. The Regiment saw service at Malabar and Goa in 1795/97 in the Kaffir War of 1835, in Egypt 1882 and the Great War 1914/18 and World War II 1939/45.

PROPERT'S SHOE POLISHES

PRINTED IN ENGLAND

Issued by
Propert Shoe Polish in 1955

BRITISH UNIFORMS
PRESENTED BY

QUICK COOKING OATS.
"The Best in any Packet"
(A Series of 25)

No. 20
THE GORDON HIGHLANDERS
The 75th (Highland) Regiment of Foot, now the Gordon Highlanders, was founded by Robert Abercromby of Tullieby in 1787. The Regiment saw service at Malabar and Goa in 1795/97 in the Kaffir War of 1835, in Egypt 1882 and the Great War 1914/18 and World War II 1939/45.

Made by
MORNING FOODS LTD
North Western Mills, Crewe

Issued by
Morning Foods in 1954

BRITISH UNIFORMS
(A Series of 25)

No. 20
THE GORDON HIGHLANDERS
The 75th (Highland) Regiment of Foot, now the Gordon Highlanders, was founded by Robert Abercromby of Tullieby in 1787. The Regiment saw service at Malabar and Goa in 1795/97 in the Kaffir War of 1835, in Egypt 1882 and the Great War 1914/18 and World War II 1939/45.

ISSUED BY

Ewbanks Ltd.
EAGLE WORKS · PONTEFRACT

Issued by
Ewebanks in 1956

BRITISH UNIFORMS OF THE 19TH CENTURY

Here we see a front and examples of the backs of some of the very many Trade manufactures who issued this particular set of 25 cards. In fact in addition to the 5 shown there are 3 other firms who issued this set, namely Horsley's Stores, The Beehive and The Direct Tea Supply company.

British Uniforms of the 19th Century
A SERIES OF 25

No. 10
THE GORDON HIGHLANDERS
The Gordon Highlanders were formed in 1881 by the Amalgamation of the 75th Stirlingshire Regiment and the 92nd Highlanders.
The Duchess of Gordon played an active part in the recruiting of the Regiment by bestowing a kiss on each intending recruit.
The drawing depicts a Private of 92nd about 1840.

Issued by
Anonymous firm 1957

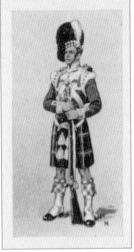

Issued by
Amalgamated Tobacco Corporation Ltd. (Mills) 1957

British Uniforms of the 19th Century
A SERIES OF 25

No. 10
THE GORDON HIGHLANDERS
The Gordon Highlanders were formed in 1881 by the Amalgamation of the 75th Stirlingshire Regiment and the 92nd Highlanders.
The Duchess of Gordon played an active part in the recruiting of the Regiment by bestowing a kiss on each intending recruit.
The drawing depicts a Private of 92nd about 1840.
FUMEZ LES FAMEUSES CIGARETTES
"MILLS"
FILTERTIPS

British Uniforms of the 19th Century
A SERIES OF 25

No. 10
THE GORDON HIGHLANDERS
The Gordon Highlanders were formed in 1881 by the Amalgamation of the 75th Stirlingshire Regiment and the 92nd Highlanders.
The Duchess of Gordon played an active part in the recruiting of the Regiment by bestowing a kiss on each intending recruit.
The drawing depicts a Private of 92nd about 1840.

Issued by
A. C. W. FRANCIS
St. Peter's Street,
Gouyave,
GRENADA. W.I.

Issued by
A.C.W. Francis 1965

British Uniforms of the 19th Century
A SERIES OF 25

No. 10
THE GORDON HIGHLANDERS
The Gordon Highlanders were formed in 1881 by the Amalgamation of the 75th Stirlingshire Regiment and the 92nd Highlanders.
The Duchess of Gordon played an active part in the recruiting of the Regiment by bestowing a kiss on each intending recruit.
The drawing depicts a Private of 92nd about 1840.

Rich Refreshing
=== *TEA* ===
UNITED DAIRIES

Issued by
United Dairies 1962

British Uniforms of the 19th Century
A SERIES OF 25

No. 10
THE GORDON HIGHLANDERS
The Gordon Highlanders were formed in 1881 by the Amalgamation of the 75th Stirlingshire Regiment and the 92nd Highlanders.
The Duchess of Gordon played an active part in the recruiting of the Regiment by bestowing a kiss on each intending recruit.
The drawing depicts a Private of 92nd about 1840.

CORGI PAPER BACK STOCKISTS
MANY TITLES AVAILABLE FROM
STEVE PRIOR
6. ROBERTSON STREET,
LONDON, S.W.8

Issued by
Steve Prior 1965

Here we some interesting examples from three different sets of Trade cards, two of which were issued before the Second World War. The first was produced by Chix Confectionary and included with packets of bubble gum in 1970. The Wizard Warrior Cards were issued in two sizes by D.C. Thompson & Co. Ltd., a London based publisher who issued very many comics such as the Hotspur, Rover, Wizard, etc. The cards were issued in two sizes, the first in 1929 which was a standard sized card and the second, as illustrated, in 1936. The first set was issued with a sectional back of 24 cards which made a picture when the set was completed, unlike the smaller card had a domino back and was therefore a set of 28 cards. The picture of the Gordon Highlander appeared in both sets. The third illustration of from a set of 20 cards titled Furs and Their History and was issued by Oxo Ltd. in 1932. Unfortunately this is the only card of a military theme and shows that odd cards can be found in a variety of sets, not just military ones. Indeed cards of individual personalities can be found just about anywhere, such as

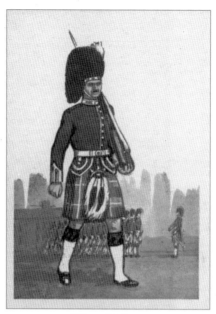

Military Uniforms
issued by Chix Confectionary 1970

Wizard Warrior
Cards issued by
D.C.Thompson

Furs and Their History
issued by Oxo Cubes 1932

Clearly the quality of these cards isn't as good as the pre-war cigarette manufacturers, but they are still very interesting. It must be remembered that the tobacco firms would have had a run of several million cards, many times that of the trade manufacturers, and therefore the cost per card to produce them was considerably less. As a result they were able to spend more money on the artwork in order to achieve more superior results.

THE BRITISH ARMY 1815

A SERIES OF 25

No. 9
92nd REGIMENT OF FOOT
This very famous regiment gave outstanding service during the campaign in the Iberian Peninsula and at Waterloo (the 92nd). Very heavy casualties were caused at Quatre Bras when the regiment was charged in open country by the French heavy cavalry. The charge by the Gordons and the Greys at Waterloo is one of the highlights of military history.

ISSUED BY

GLENGETTIE TEA

Battlebridge House, London S.E.1.

Black Back

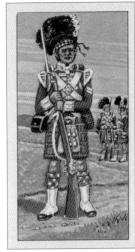

The British Army 1915
issued by Glengettie Tea 1976

THE BRITISH ARMY 1815

A SERIES OF 25

No. 9
92nd REGIMENT OF FOOT
This very famous regiment gave outstanding service during the campaign in the Iberian Peninsula and at Waterloo (the 92nd). Very heavy casualties were caused at Quatre Bras when the regiment was charged in open country by the French heavy cavalry. The charge by the Gordons and the Greys at Waterloo is one of the highlights of military history.

ISSUED BY

GLENGETTIE TEA

Battlebridge House, London S.E.1.

Blue back

Military issued by
John Brindley (printers) 1967

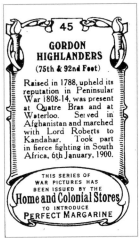

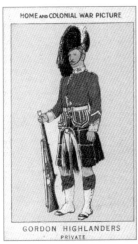

War Pictures (Different)
issued by Home & Colonial Stores Ltd in 1916

Here we have the backs of the next set of examples. Soldiers of the King was issued both with adhesive backs and without, and also by the United Kingdom Tobacco Co. The European War Series was issued by several tobacco and Trade firms.

OFFICERS FULL DRESS

A SERIES OF 36

33

THE GORDON HIGHLANDERS

Colonel Robert Abercromby gathered a body of young Highlanders round him in 1788, and so founded this famous kilted Regiment. It was the "Gordons" at Waterloo who grasped the stirrups of the Scots Greys, and shouting "Scotland for Ever," ran with the Cavalry towards the foe, routing a solid column of the enemy, and capturing 2,000 prisoners. The "Gordons" added renown to their past glory in the Great War (1914-1918), fighting from Mons to Famars.

THIS SURFACE IS ADHESIVE

UNITED KINGDOM TOBACCO COMPANY (1929)
AND ASSOCIATED COMPANIES

Officers Full Dress
issued by U. K. Tob. Co.
1936

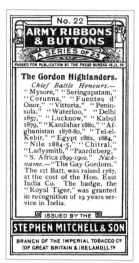

No. 22
ARMY RIBBONS & BUTTONS
A SERIES OF 25

PASSED FOR PUBLICATION BY THE PRESS BUREAU 15.11.16

The Gordon Highlanders.
Chief Battle Honours.— "Mysore," "Seringapatam," "Corunna," "Fuentes d' Onor," "Vittoria," "Peninsula," "Waterloo," "Delhi 1857," "Lucknow," "Kabul 1879," "Kandahar 1880," "Afghanistan 1878-80," "Tel-el-Kebir," "Egypt 1882, 1884," "Nile 1884-5," "Chitral," "Ladysmith," "Paardeberg," " S. Africa 1899-1902." *Nickname.*—"The Gay Gordons." The 1st Batt. was raised 1787, at the cost of the Hon. East India Co. The badge, the "Royal Tiger," was granted in recognition of 19 years service in India.

ISSUED BY THE
STEPHEN MITCHELL & SON
BRANCH OF THE IMPERIAL TOBACCO Cº
(OF GREAT BRITAIN & IRELAND),LTº

Army Ribbons & Buttons
issued by Stephen Mitchell
1916

MITCHELL'S CIGARETTES

Gordon.

Descended from Sir John de Gordoune, whose daughter married a son of Sir William Seton who took the name of Gordon. His son was created Earl of Huntly, and George, sixth Earl, became Marquis in 1599. George, fourth Marquis, was created Duke in 1684, a title now extinct. The Gordon Highlanders (92nd Regiment) was raised in 1794 by Jane, Duchess of Gordon.
Badge. The Rock Ivy.

STEPHEN MITCHELL & SON
GLASGOW
ISSUED BY THE IMPERIAL TOBACCO Cº
(OF GREAT BRITAIN & IRELAND) LTº

Scottish Clan Series
issued by Stephen Mitchell
1903

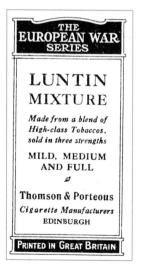

SOLDIERS OF THE KING

A SERIES OF 36

13
THE GORDON HIGHLANDERS

The "Gay Gordons" were raised in 1788, and their regimental march *Highland Laddie* is known the world over. Highland uniform was worn until 1808, when it was discarded, but resumed again in 1882; their tartan is Gordon. In the days before barracks existed, soldiers were commonly billeted in ale houses, and drummers used to go round playing the "tap toe", signifying quarters must not be left—the tattoo is a survival of the practice. The Gordon Highlanders are allied to the 48th Highlanders of Canada; 5th Battalion of Australian Infantry and the Capetown Highlanders (Duke of Connaught and Strathearn's Own).
This surface is adhesive
GODFREY PHILLIPS LTD. and Associated Companies

Soldiers of the King
issued by Godfrey Phillips
1939

THE EUROPEAN WAR SERIES

LUNTIN MIXTURE

Made from a blend of High-class Tobaccos, sold in three strengths

MILD, MEDIUM AND FULL

Thomson & Porteous
Cigarette Manufacturers
EDINBURGH

PRINTED IN GREAT BRITAIN

The European War Series
issued by Thompson & Porteous 1915

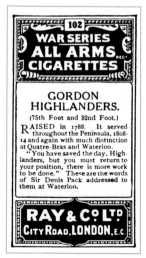

102
WAR SERIES ALL ARMS CIGARETTES

GORDON HIGHLANDERS.
(75th Foot and 92nd Foot.)

RAISED in 1788. It served throughout the Peninsula, 1808-14 and again with much distinction at Quatre-Bras and Waterloo.
"You have saved the day, Highlanders, but you must return to your position, there is more work to be done." These are the words of Sir Denis Pack addressed to them at Waterloo.

RAY & Cº LTº
CITY ROAD. LONDON, E.C.

War Series
issued by Ray & Co. Ltd
1915

The full colour splendour of the uniforms is shown here with six examples from various manufacturers, including some of the smaller ones. The Scottish Clan Series is particularly interesting and was also issued by Stephen Mitchell in 1903.

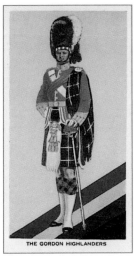

Officers Full Dress
issued by U. K. Tob. Co.
1936

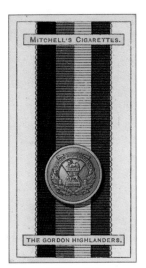

Army Ribbons & Buttons
issued by Stephen Mitchell
1916

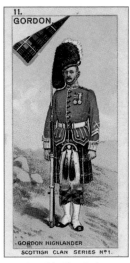

Scottish Clan Series
issued by J. & F. Bell Ltd
1903

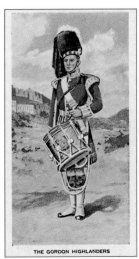

Soldiers of the King
issued by Godfrey Phillips
1939

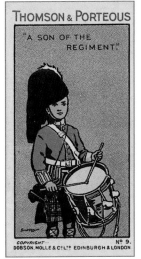

The European War Series
issued by Thompson &
Porteous 1915

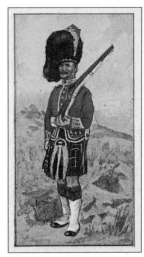

War Series
issued by Ray & Co. Ltd
1915

REGIMENTAL STANDARDS & COLOURS

A number of cigarette/tobacco manufacturers produced cigarette cards of Regimental Standards and Colours, including John Player & Sons, Gallahers and Godfrey Phillips, and although they are very colourful, unfortunately many are inaccurate. The following examples from John Player & Sons of Nottingham illustrate the point. The first shows the Regimental Colour of the 1st battalion of the Gordon Highlanders and was issued in 1903, titled Badges & Flags of British Regiments. Basically it is correct in that it shows the Colour that was presented to the 75th (Stirlingshire) Regiment of Foot in 1863, shortly after 'Stirlingshire' was added to its title. It is yellow, the facing colour of the regiment and a good example of the style of the Regimental Colour of the pre- 1881 period. However it shows a King's Crown, whereas it would have been a QV Crown. It should be noted that it has the badge of the Sphinx, which was awarded to the 2nd battalion, previously The 92nd (Gordon Highlanders) Regiment of Foot, and therefore was added after 1881. It is also apparent that the artist/reseacher didn't realise that new Colours were presented to the 1st battalion in 1899, but as can be seen this error was rectified the following year in 1904 when the set was re-issued. The second illustration is now correct for the period and shows the revised style of the Regimental Colour, which was introduced in 1881 at the time of the Cardwell Reforms. After their amalgamation both battalions were entitled to show each others Badges (i.e. the Royal Tiger of the 75th and Sphinx of the 92nd). It is interesting to note, that unlike many English county regiments, both battalions of the Gordon Highlanders retained their pre 1881 facing colours of yellow, as that was the allocated colour for all Scottish regiments, except for the Black Watch which was a 'Royal' regiment with blue facings.

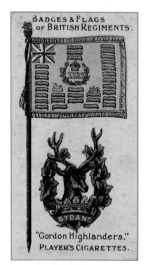

1903 Issue

Reverse of 1903 Issue Badges
& Flags of British Regiments

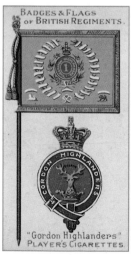

1904 Issue

In this page are some beautiful examples from the Gallaher set of Regimental Colours & Standards which was issued in 1899. Clearly the artist was very much 'on the ball' as these Colours were only presented to the 1st battalion on the 18th September by H.R.H. The Prince of Wales, at Ballater. In view of the timescale in painting the cards, the printing and issuing of them, the artist must have been aware sometime in advance of the presentation of new Colours.

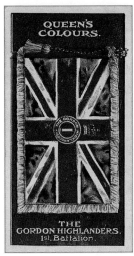

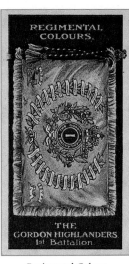

King's Colour Reverse of Cards Regimental Colour

In 1930 John Player & Sons issued a new set of Regimental Standards & Cap Badges. This was particularly interesting set as it was the first to be issued after the First World War and after most regiments, in particular the English regiments, regained their pre-1881 facing colours. Here we see the King's Colour, or First Colour as it is sometimes known, of the 2nd battalion which was presented to it by H.M. King George V at Delhi on the 11th December 1911. As can be seen it shows 10 Battle Honours which were not added until 1919. From 1881 until 1919 no Battle Honours were incorporated on the King's Colour, only the Regimental one. Although the practice of placing Battle Honours was abolished in 1881, after the many Honours that were awarded during the First World war regiments were allowed to incorporate up to 10 on the King's Colour. The set was also issued in New Zealand by W.D. & H.O. Wills in 1928.

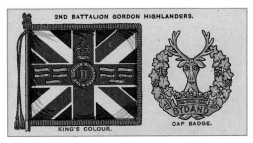

Regimental Standards & Cap Badges
issued by
John Player & Sons in 1930

Here further examples of Regimental Colours from different manufacturers are shown. To the right is one by James Taddy & Co. issued in 1908. Taddy's was a small cigarette firm, but they produced some really superb military sets of cards, such as this set of 25 Territorial Regiments. It represents the 5th battalion of the Regiment, but as can be seen it bears no Battle Honours. This changed after the First world War. Below is another set from John Players & Sons and features one from the Military Series issued in 1900. The other pictures are silk issues the first by Phillips and appears to show the 1894 Regimental Colour before the 2nd battalion was presented with a new ones in 1911 as shown by B. Morris.

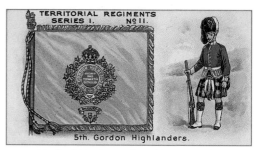

Territorial Regiments by Taddy & Co. 1908
(N.B. the numeral V should be in the top right hand corner)

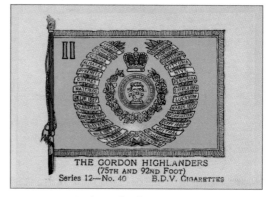

Regimental Colours Series 12
issued by Godfrey Phillips 1914

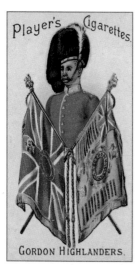

Military Series
by John Player & Sons 1900

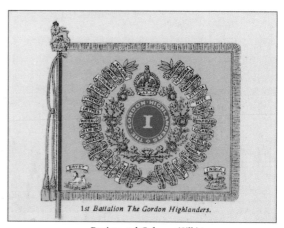

1st Battalion The Gordon Highlanders.

Regimental Colours (Silk)
issued by B. Morris & Sons Ltd in 1916

The John Player set of Uniforms of the Territorial Army had a number of changes and varieties, such as the title 'London Scottish' both central and offset as is shown. The card from Well Known Ties was also issued in a standard size card, in addition to the larger one from a packet of 20 cigarettes. The European War Series was issued by a number of Trade firms, including this Edinburgh one.

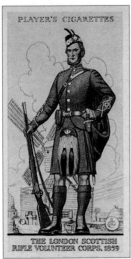

Uniforms of the T.A.
Issued by John Player & Sons
1939

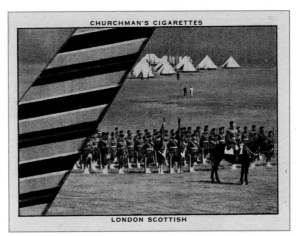

Well Known Ties - A Series
issued by W.A. & A.C. Churchman
1934

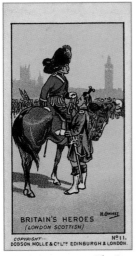

The European War Series
issued by Fairley's Restaurant
1916

The European War Series
issued by Thompson &
Porteous 1915

VICTORIA CROSS WINNERS

The Gordon Highlanders have gained 17 VCs, 11 of which are reflected in cigarette cards. Listed below are 5 examples of the 9 from the series of 125 by James Taddy & Co. which feature winners from the Gordon Highlanders, more than any other unit. The card of the Victoria Cross is from Honours & Ribbons, also by James Taddy.

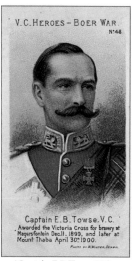

Captain E.B. Towse V.C.

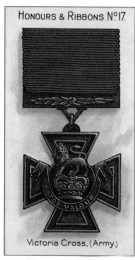

Honours & Ribbons

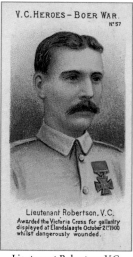

Lieutenant Robertson V.C.

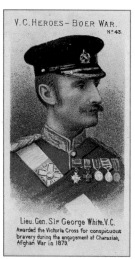

Lieut-Gen. Sir George White V.C.

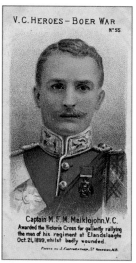

Captain M.F.M. Meiklejohn V.C.

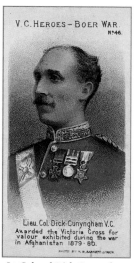

Lt-Colonel Dick Cunyngham V.C.

Field Marshal Sir George White, VC ,GCB, OM, GCSI, GCMG, GCIE, GCVO was probably the most distinguished military leader that the Gordon Highlanders has produced. He was born in July 1835 in Ireland, educated at King William's College Isle of Man and Sandhurst, being gazetted into the 27th Inniskilling Fusiliers in November 1853, He served in the Indian Mutiny and in the North West Frontier with his Regiment, before being promoted to Captain into the 92nd Highlanders in 1863 and Major in 1873. He won his Victoria Cross on the 6th October 1879 at Charasiah whilst in command of

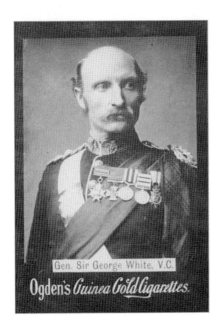

the right attack on the fortified hill. Whilst climbing the hill with two companies of men he came upon a strongly defended force of the enemy which outnumbered his own by about eight to one. His men were exhausted, and in order to save the situation, he grabbed a rifle and shot the leader dead, which intimidated the enemy. He again showed his courage at the Battle of Kandahar the following year by exposing himself in order to relief a difficult situation. His actions in the Afghan War brought him to the attention of his superiors and he was promoted the following year. He took part in the Nile Expedition of 1884, Burma 1885-6 and the Zhob Campaign. He is probably best known for his defence of Ladysmith against all odds in the Boer War. He became Colonel of the Regiment in 1897. The cards shown are from Ogdens Guinea Gold series issued 1900-01, with many varieties.

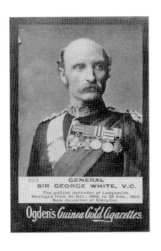
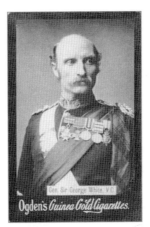
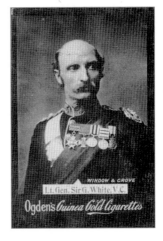

Adkin & Sons produced two nice sets of Soldiers of the Queen, one of 50 and one of 60 cards, and although they had the same subjects there were some minor changes as shown. The same portrait appears in the Wills set of Royalty, Notabilities & Events 1900-02. The set from Cohen Weenen & Co. Ltd.. had two different backs.

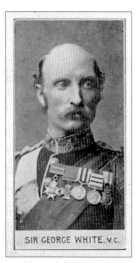

Soldiers of the Queen (50)
issued by Adkin & Sons
1900

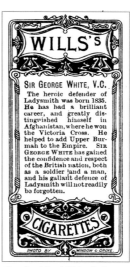

Royalty, Notabilities & Events
1900-02
issued by Wills Overseas

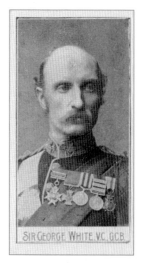

Soldiers of the Queen (60)
issued by Adkin & Sons
1900

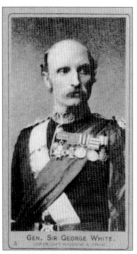

Boer War Series A
by The American Tobacco Co.
1901

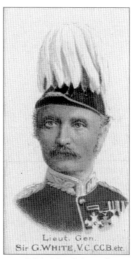

Celebrities Coloured
issued by Cohen Weenen
1901

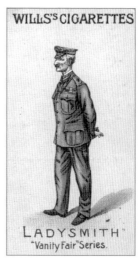

Vanity Fair
issued by W.D. & H.O. Wills
1902

Further Examples of Sir George White on cigarette cards are shown. The Transvaal Series by W.D. & H.O. Wills consisted of 66 subjects, but there were many alterations to reflect changes in the Boer War and different brands were advertised on the backs. The Salmon & Gluckstein set of 40 subjects is well sought after by collectors and some of cards are more difficult to obtain, Sir George White being one of them.

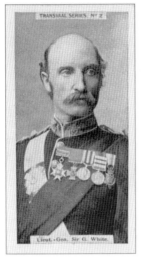
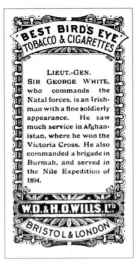
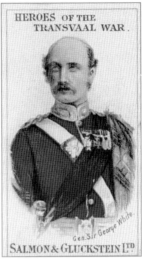

Transvaal Series (White Border)
issued by W.D. & H.O. Wills
1901

Heroes of the Transvaal War
issued by Salmon & Gluckstein
1901

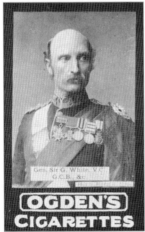
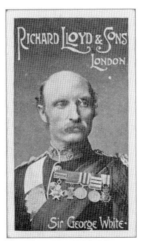
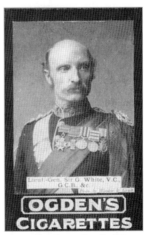

Prominent British Officers
issued by Ogdens (Tabs)
1901

Boer War Celebrities
issued by Richard Lloyd
1899

Leading General at the War
issued by Ogdens (Tabs)
1901

Lieutenant William Robertson was born at Dumfries in 1865 and joined the army in December 1884. He won his VC during the Boer War at the Battle of Elandslaagte on the 21st October 1899 whilst a sergeant-major. During the final advance on the enemy's position he led each successive rush, exposing himself to both artillery and rifle fire in order to encourage his men. After the main position had been captured he led a small party to seize the Boer camp, and despite heavy fire, in which he was twice wounded, was captured. He was recommended for the award by Brigadier Ian Hamilton, a former officer of the Regiment, who witnessed the second part of the incident. During the First World War he was Recruiting Staff Officer at Edinburgh with the rank of Lt-Colonel. One of his sons was also commissioned into the Regiment, but unfortunately was killed at Beaumont Hamel.

The cigarette card to the left was one of a series of 'Tab' issues by Ogdens of Liverpool at the time of the Boer War, many of which featured Victoria Cross winners and leading generals.

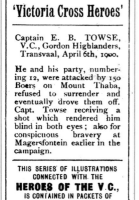

Imperial Interest
issued by Ogdens (Tabs) 1901

Captain Ernest B.B. Towse was born in 1864 and gazetted into the Wiltshire Regiment 1885, transferring to the Gordon Highlanders in 1886. Before the South African War he had previously served in the Malakand Relief Force, the NW Frontier of India and Tirah. He won his VC on the 30th April 1900 on Mount Thaba, where with only twelve men, he defended the position against a Boer force of 150. Despite being far away from support, and being asked to surrender he ordered his men to open fire to defend the position, and to charge forward. This despite the fact that he was severely wounded with both of his eyes shattered. He has since been appointed Sergeant-at-Arms to three successive sovereigns.

The cigarette card is from a set of 50 by Ogdens and was issued in 1901.

Victoria Cross Heroes issued by Ogdens 1901

Corporal John Frederick MacKay, a university student, joined the 1st battalion of the Gordon Highlanders as a private, and served with the Regiment on the North-West Frontier of India and with the Tirah Expeditionary Force 1897-98. He took part in all of the principal engagements including Dargai, Tirah Maidan, Warren Valley, Bara River and operations in Dwatoi country. He went with his battalion to South Africa and took part in operations in the advance of Kimberley in 1899, including the engagement at Magersfontein. Later he took part in operations in the Orange Free State and the Transvaal. It was in the Transvaal at the action at Doornkop, near Johannesburg on the 20th May 1900, that he won his Victoria Cross by repeatedly rushed forward, whilst under withering fire at short range, to attend wounded comrades and dressing their wounds. This he continued to do whilst without shelter, and in one instance he carried a wounded soldier from the open under heavy fire to the shelter of a boulder. He was also recommended for the Victoria Cross for an act of gallantry in the action at Leehoehoek near Krugerdorp on the 11th July, at which Captains Gordon and Younger received their V.C.s, the latter posthumously.

Shortly afterwards Corporal MacKay was commissioned into the King's Own Scottish Borderers, and in May 1903 Captain MacKay was seconded to the Southern Nigeria Regiment. He accompanied the expeditions to the Ime River, Cross River and Ibibio Country in the following two years, and in 1905-6 the Bende Hinterland Expedition. He also served with the Northern Nigeria Regiment in 1907 and commanded the Ogumi Patrol. He received the West Africa General Service Medal with four clasps and was twice mentioned in despatches. He was transferred on promotion from the King's Own Scottish Borders to the Argyle and Sutherland Highlanders in 1907. He served in the France during the First World War with his Regiment in 1915-16, returning in 1916 to be promoted to command the 2/6th battalion of the Highland Light Infantry, an appointment he held until it was disbanded. After the war Lt-Colonel MacKay went to the 1st battalion. Once again a soldier of the Regiment distinguished himself and gained rapid promotion as a result.

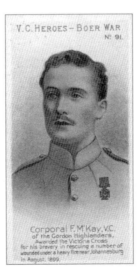

The cigarette card is another from Taddy's set of 125 V.C. Heroes.

V.C. Heroes - Boer War
issued by James Taddy & Co. 1902

Lt-Colonel Dick-Cunyngham was born in June 1851 and gazetted into the 92nd Highlanders in February 1872 and spent the next eight years in India on various assignments, including service in the Afghan War. It was at the assault on the Takhi-i-Shah in December 1879, as a lieutenant, that he won his VC, by exposing himself to the full fire from the enemy in order to rally the men who were wavering after their own officer had fallen. He was killed in South Africa whilst in command of the 2nd battalion.

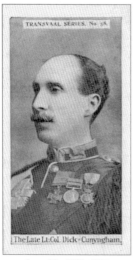

Issued by Wills 1901

Transvaal Series
Issued by Players 1902

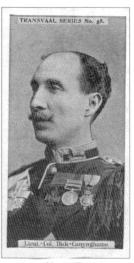

Issued by Wills 1901.

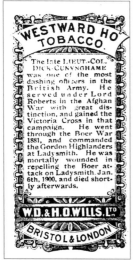

Issued by W.D. & H.O. Wills
1901

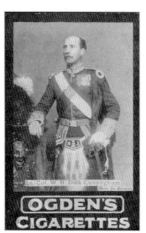

Leading Generals
issued by Ogdens 1901

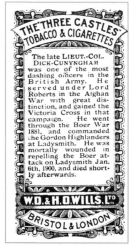

Issued by W.D. & H.O. Wills
1901

Captain Matthew F.M. Meiklejohn was born in November 1870, educated at Fettes College Edinburgh and joined the Gordon Highlanders in India in 1891, where he saw action four years later during the relief of Chitral. He won his VC at the Battle of Elandslaagt, during the Boer War in 1899, when he rushed forward to rally the men after they had lost their own leaders due to sudden heavy crossfire, after the main Boer position had been captured. In doing so he was fully exposed and was badly wounded in four places. Nevertheless the situation was saved, although it cost him his right arm.

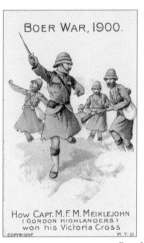 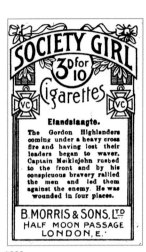

Boer War 1900
issued by B. Morris & Sons Ltd. in 1900

Major Meiklejohn was killed in an accident in London in 1913 whilst trying to avoid some children with his runaway horse. Apart from the card from the Taddy set of V.C. Heroes, which has already been illustrated, two further examples are shown. The first is from the set Boer War 1900 which consists of 20 VC winners, by B. Morris & Sons Ltd., a small tobacco firm based in London. These cards are very scarce and difficult to find in nice condition. The second one is from an overseas set of Heroic Deeds, which was issued to British Garrisons, mainly in India. It consisted of 30 subjects and are beautifully painted. This is one of very many military sets produced by W.D. & H.O. Wills, a large Bristol based firm. It was surprising that many of the best military sets were only issued outside the United Kingdom. The set was also issued by the British American Tobacco Company with a plain back for issue in China.

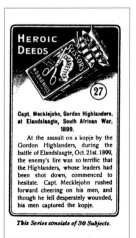 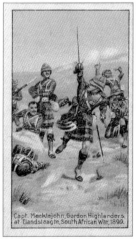

Heroic Deeds
issued by W.D. & H.O. Wills Overseas in 1913

Both Captain Younger and Captain Gordon received their respective V.C.s for heroism at the same incident during the Boer War. On the 11th July 1900 during the action at Leehoehoek near Krugersdorf, Captain Gordon, who was in command of a small party, and accompanied by Captains Younger and Allen, succeeded in dragging an artillery wagon to safety, despite being under constant and heavy enemy fire. He then ran out again, this time alone, in order to save one of the guns. Then with great coolness under fire, he succeeded in fastening a drag rope to the gun. Captain Younger with a party of volunteers raced forward, and together they tried to pull the gun to safety. However while moving the gun Captain Younger and three men were hit, and realising that further attempt would be useless with further casualties, Captain Gordon order the men to safety. He then saw that the wounded were safely away and retired himself although Captain Younger was mortally wounded and died shortly afterwards. Corporal MacKay who was later recommended for the V.C., assisted Captain Gordon in retrieving his body.

Captain William Eagleson Gordon was born in May 1866 and joined the 1st battalion of the Regiment in June 1888, having come from the Militia. He saw action in the Chitral Relief Expedition in 1895 and was promoted to Captain in 1897. He took part in the operations on the NW. Frontier of India and was appointed Adjutant to the 1st battalion from January 1899 to January 1903. During the Boer War he took part in the Advance on Kimberley and was badly wounded at Magerfontein, but after having recovered he was again wounded at Paardeberg,. After the war he reached the rank of Brevet Colonel and was appointed ADC. to the King. Although he served in the First World War in 1914, he was taken prisoner, but was exchanged two years later.

Captain Younger was awarded the V.C. posthumously under new regulations of 1902.

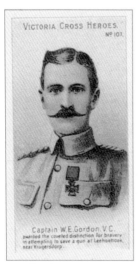

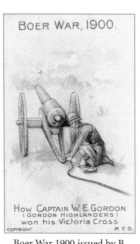

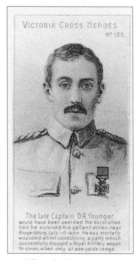

Victoria Cross Heroes
issued by James Taddy & Co.

Boer War 1900 issued by B.
Morris & Sons Ltd.

Victoria Cross Heroes
issued by James Taddy & Co.

Piper George Findlater received his Victoria Cross for what must be regarded as an amazing act of heroism. During the attack on the Dargai Heights in the North West Frontier of India on the 20th October 1897 he was wounded in both feet and was unable to stand. However he sat up whilst under heavy fire and played the regimental march in order to encourage the charge of the Regiment. He was personally decorated by H.M. The Queen at Netley Hospital. Not surprisingly this act attracted much attention back home and over the coming years many of the sets of Victoria Cross winners showed this gallant soldier. The first is one from the Ogdens set of 50 issued in 1901, followed by Heroic Deeds, issued by Wills Scissors cigarettes in 1913. Another example is from the set of 25 subjects by John Players & Sons titled Victoria Cross in 1914, followed by a Taddy V.C.

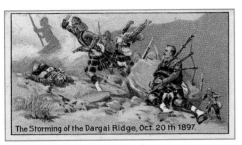

Heroic Deeds
issued by Wills Overseas in 1913

Victoria Cross Heroes
issued by Ogdens 1901

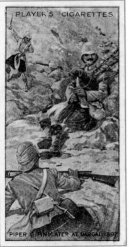

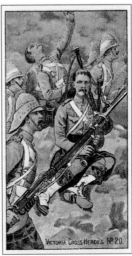

Victoria Cross
issued by John Player & Sons in 1914

Victoria Cross Heroes
issued by Taddy & Co. 1901

Captain J.A. Otho Brooke V.C. was born on 3rd February 1884, the son of a former officer in the 92nd (Gordon Highlanders). He was educated at Wellington and Sandhurst, where he received the Sword of Honour, and was commissioned into the Gordon Highlanders on 5th August 1905, joining the 1st battalion later that year. In 1907 he was promoted into the 2nd battalion in India and in 1911, as he was the senior subaltern, he received the new Regimental Colour from H.M. The King at Delhi Durbar at the ceremony in December. He was a very keen sportsman and a splendid shot, killing many wild game such as leopards and bison. He left India in 1913 and was in Egypt when the First War broke out, travelling to Belgium in October 1914. He was soon in action with his battalion and won his Victoria Cross whilst leading a charge of about 100 men against a very much superior force of advancing Germans who were about to break through the line. He was Assistant Adjutant at the time and was whilst taking a message from his Commanding Officer from one end of the line to the other that he noticed the imminent danger, and with great promptitude and bravery, he quickly gathered all of the men he could muster and drove back the enemy. The situation was saved, but unfortunately he was killed in the action. He was promoted to Captain after his death, backdated to the September, and also mentioned in despatches.

The set of V.C. Heroes was originally issued by Thompson & Porteous in 1916 as one of 44 cards. It was a small tobacco firm based in Leith Street, Edinburgh, later bought by Godfrey Phillips in 1926. It only produced six sets, four of them of a military theme. The set was also printed with the firm's name at the top of each card, although these are quite difficult to obtain. It was later issued by Alex Ferguson, the confectionery firm, with a variety of different adverts on the back, such as Caramel Walnuts, Ferguson's Flake Chocolate and Ferguson's Tea Rooms. It was also printed as an anonymous issue for an unknown firm.

Although L/Cpl William Kenny is also shown, it is unfortunate that neither of the other two Victoria Cross winners are shown on any cigarette cards, namely Private George I. McIntosh, of the 1/6th battalion, and Lieutenant Alan E. Ker of the 3rd battalion, both of whom showed tremendous courage under fire.

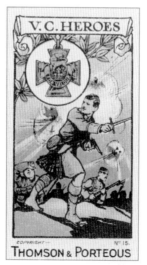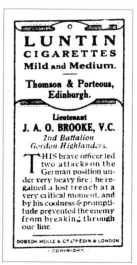

V.C. Heroes
issued by Thompson & Porteous
1916

Lance-Corporal William Kenny joined the Gordon Highlanders as a drummer in the 2nd battalion, and served in the First World War. He gained his V.C. on the 23rd October 1914 near Ypres for rescuing wounded comrades on no less than five occasions, under very heavy fire in the most fearless manner. He had twice previously saved machine guns by bringing them out of action. On numerous occasions he had carried urgent messages under fire and under very dangerous circumstances. He appears on many cards.

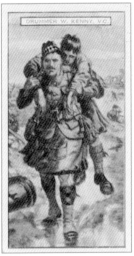
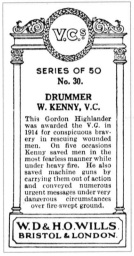

V.C.s
issued by W.D. & H.O. Wills (New Zealand) 1926

War Series L
issued by Murray & Sons 1916

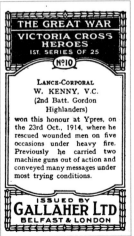
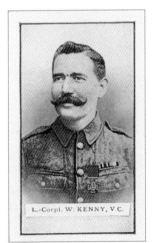
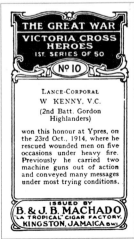

The Great War Victoria Cross Heroes
issued by Gallaher Ltd. 1915-18

issued by
B. & J.B. Machado 1916

Regimental Standards & Cap Badges
issued by John Player & Sons
1930

London Ceremonials
issued by Stephen Mitchell 1928

Here we see further examples of the London Scottish. To the left is one from the John Player set of Regimental Standards & Cap Badges which was also issued by W.D. & H.O. Wills in New Zealand in 1928. Below it is one from a set of 40 London Ceremonials, which was issued by Stephen Mitchell in 1928, also by B.A.T. in 1929. On the bottom row is a card of the Duke of Argyll from the Wills set of the Coronation Series which was issued in 1902. The Duke was the Honorary Colonel of the London Scottish from 1900-14, until succeeded by Earl Haig. Next is an interesting one from Godfrey Phillips which was of 25 Territorial units, and then one from a similar set by Woods of Preston, painted by Harry Payne.

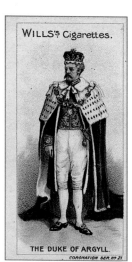

Coronation Series
issued by W.D. & H.O. Wills
1902

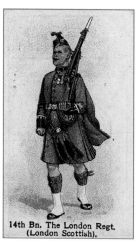

Territorial Series
issued by Godfrey Phillips
1908

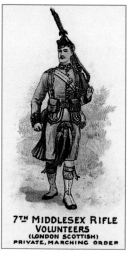

Types of Volunteer &
Yeomanry issued by W.H. &
J. Woods 1902

PERSONALITIES

Both battalions of the Gordon Highlanders produced a number of distinguished soldiers and this is reflected in the set Boer War Series (Coloured) by F. & J. Smith in 1901. It has 50 subjects and five of them are associated with the Regiment. Smiths was a small tobacco firm based in Glasgow which consolidated with Stephen Mitchell in 1927.

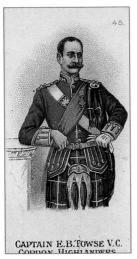

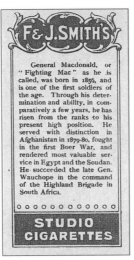

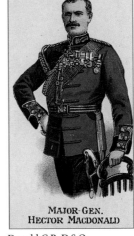

Captain E.B. Towse V.C.

Major-General Hector MacDonald C.B. D.S.O.

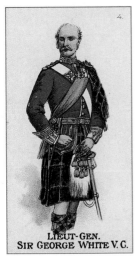

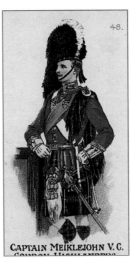

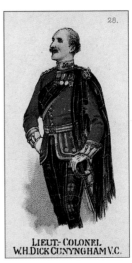

Lieut-Gen. Sir George White V.C.

Captain M.F.M. Meiklejohn V.C..

Lt-Colonel Dick Cunyngham V.C.

General Sir Ian S.M. Hamilton GCB, GCMG, DSO was born in 1853 and commissioned into the army in 1873. As an officer in the 92nd (Gordon Highlanders) he served in eight campaigns, all with distinction. However he is probably best known for commanding the unfortunate and ill-fated Gallipoli force. He succeeded General Sir Charles Douglas as Colonel of the Regiment in October 1914 and remained its Colonel until June 1939. He appeared in several cigarette card sets including many of Ogdens. In fact Ogdens show him in 4 different ranks, two of them shown. Also shown are Cohen Weenen and Wills Transvaal Series.

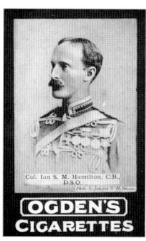

General Interest numbered issued
by Ogdens Ltd 1899

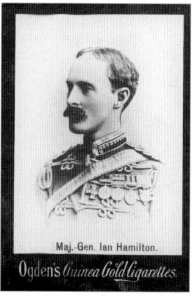

Boer War & Miscellaneous Base D
issued by Ogdens Ltd 1900

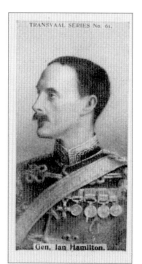

Transvaal Series
issued by W.D. & H.O. Wills
1901

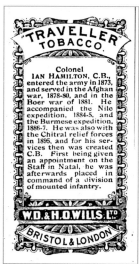

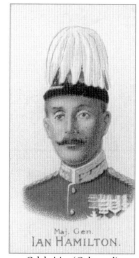

Celebrities (Coloured)
issued by Cohen Weenen
1901

The following examples, together with their backs, show General Hamilton at different times of life. The first is from the Wills set of Vanity Fair which was issued with a variety of subjects, not just military, in 1902 just after the Boer War. The second is from the Singleton & Cole set of 35 Famous Officers issued in 1915. It was a very small firm, formed in 1870 at Shrewsbury. Finally there is a card from the Ardath set of 25 Famous Scots which was issued in 1935 and clearly show him in later life.

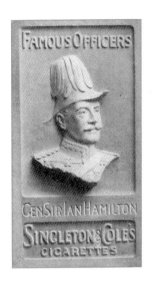
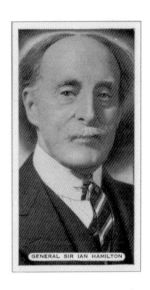

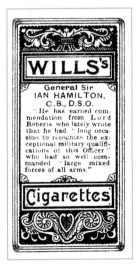
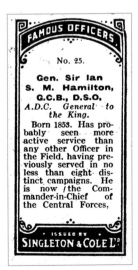
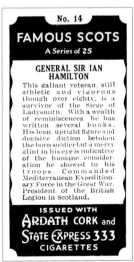

Vanity Fair issued by W.D. & H.O. Wills 1902	Famous Officers issued by Singleton & Cole 1915	Famous Scots issued by Ardath Tob. Co. 1935

Further examples of cards with personalities are shown, the first being from the set of Clan Tartans (2nd Series) by Stephen Mitchell and features Sir Hugh Rose who was the Colonel of the 92nd Highlanders from 1866-69. The other four cards are all from The South African Series by Gallahers, a company based in Belfast.

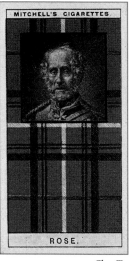

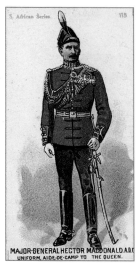

Clan Tartans - 2nd Series
issued by Stephen Mitchell in 1927

Major-General Hector
MacDonald

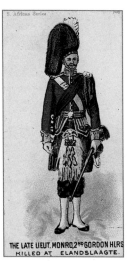
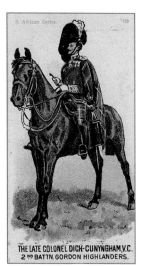
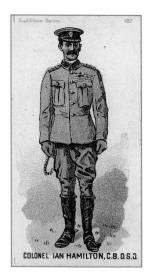

Lieutenant Monro

Lt-Colonel Dick Cunyngham
V.C.

Colonel Ian Hamilton

The South African Series issued by Gallaher Ltd

Major-General Hector Archibald MacDonald CB, DSO was born in 1856 and entered the 92nd (Gordon Highlanders) in 1870 as a private, rising through the ranks and being commissioned in 1880, after having served with gallantry in the Afghan War 1879-80. He was at the Battle of Majuba Hill during the First Boer War of 1881, and served in the Nile Expedition, distinguishing himself at the Battle Of Omdurman. He earned himself the nickname of 'Fighting Mac' with promotion coming rapidly, and although he served in the Royal Fusiliers for a while, he returned to command the Highland Brigade in South Africa in succession to General Wauchope. He was wounded at the Battle of Paardeberg, but continued to serve in the war being promoted to the rank of Major-General. He was also ADC to the Queen. It is a tribute to his military qualities that in a relatively short period he rose from the ranks to such a senior position. The four cigarette cards shown are from Ogdens Guinea Gold series of sets. The large one is from Boer War & Misc. and had 153 subjects. On the bottom row is one from the smaller set of the same series, although it had 186 subjects. The next is from the numbered series and the last one from the Boer War & Actresses set of 58 cards. The cards show his changes in rank and also some of the very many varieties that appear such as the different number of buttons, the position of the caption and numbers of medals showing, etc.

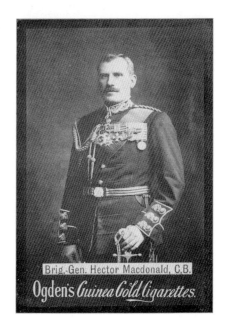

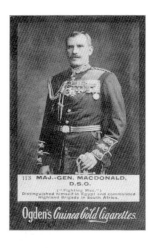

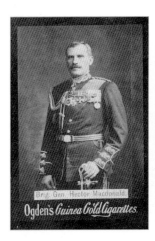

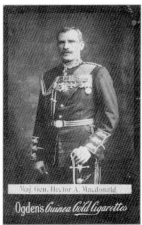

Here are a number examples from the various sets under the title of Transvaal Series which was issued by both W.D. & H.O. Wills and John Player & Sons. Four of them are from the set of 66 with a white border and again illustrate the fact that there were changes to both the front and back, in addition to different brands. The Non-Descriptive set was issued by both Wills & Players. There was also a black border set of 50.

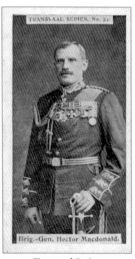

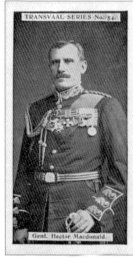

Transvaal Series
issued by Wills 1901.

Transvaal Series (Non-Descriptive)
issued by W.D. & H.O. Wills 1902

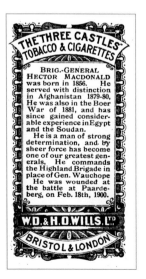

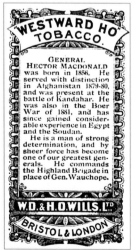

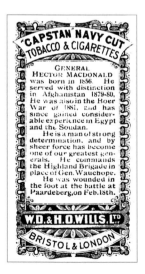

The Transvaal Series (White Border)
issued by W.D. & H.O. Wills 1901

Here we see an interesting trade issue from Lever Bros., makers of Sunlight Soap. It was from a set of 39 issued in 1901. The Ogdens Tab issue had several different backs, (i.e. Prominent British Officers, Leading Genearals with and without text & Lucky Strike). The Celebrities is from the B/W set of 65 by Coven Weenen, and finally the Boer War Generals set, which was also issued by Lambert & Butler and Muratti.

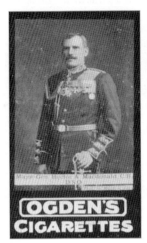

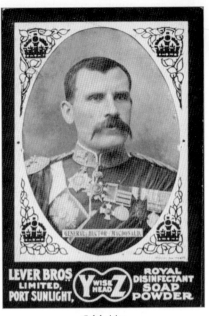

Leading Generals at the War
(Without text)
issued by Ogdens (Tabs)
1901

Celebrities
issued by Lever Brothers
(Manufacturers of Sunlight Soap)
1901

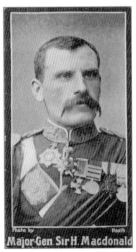

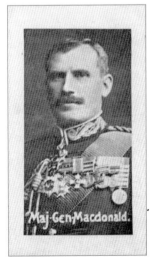

FOR THE
PIPE .

SMOKE

CHURCHMAN'S
Tortoise-shell
SMOKING
MIXTURE

Celebrities (B & W)
issued by Coven Weenie
1901

Boer War Generals (CLAM)
issued by W.F.. & AC. Churchman's
1901

Further examples of Major-General Hector MacDonald are shown, the first being from Soldiers of the Queen by Adkin & Sons, of which there are two varieties, and the second from the American Tobacco Company, of which there also two varieties. It was issued both numbered and unnumbered. Below is Heroes of the Transvaal War by Salmon & Gluckstein, back and front, and finally another example from Cohen Weenen Celebrities.

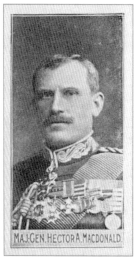

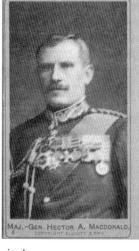

Soldiers of the Queen
issued by Adkin & Sons 1900

Boer War Series A
issued by the American Tobacco Company 1901

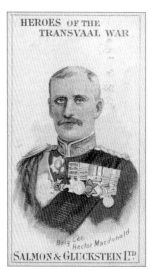
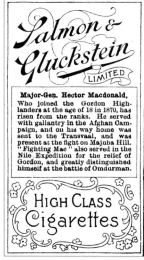
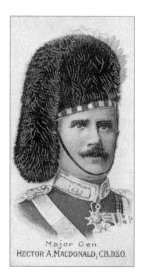

Heroes of the Transvaal War
issued by Salmon & Gluckstein
1901

Celebrities (Coloured)
issued by Cohen Weenen
1901

General Sir Charles Douglas was born in 1850 and joined the 92nd Highlanders in 1869. He saw service in the Afghan War 1879-80 and during the First Boer War, both with his Regiment. He then rose to high rank, becoming Adjutant General from 1904-09 and Chief of the Imperial General Staff in 1914. He also served as the Colonel of the Gordon Highlanders from June 1912 until October 1914. Some examples of him are shown.

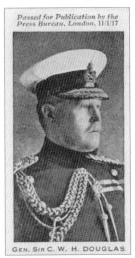

Military Portraits
issued Wills Scissors and B.A.T
1917

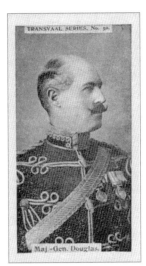

Transvaal Series
issued by W.D. & H.O. Wills
1901

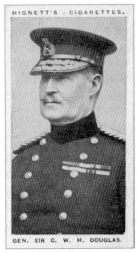

Military Portraits
issued by Hignett Bros
1914

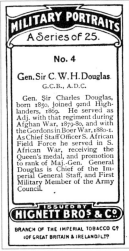

Military Portraits
issued by Hignett Bros.

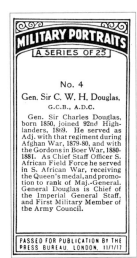

Military Portraits
issued by B.A.T. 1917

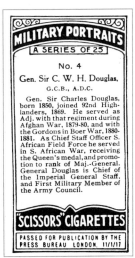

Military Portraits
issued by Wills Overseas

Major-General J.A.L. Haldane CB, DSO was commissioned into the Regiment in September 1882, and served in the Waziristan expedition of 1894-5 as an orderly officer to Sir William Lockhart. He later served with the 1st battalion in the relief of Chitral, the Tirah and various actions in the NW Frontier of India. He took part in operations in the Natal during the Boer War, including the Battle of Elandslaagte, where he was severely wounded. Later in the Transvaal he was again wounded and taken prisoner, but escaped. During the Russo-Japanese War of 1904-05 he was military attache to the Japanese Army in Manchuria. He became a brigade commander in 1912 and was later promoted to Major-General.

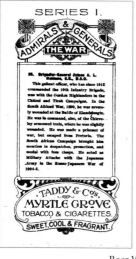

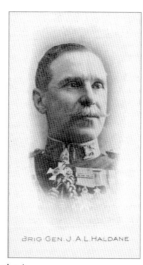

Boer War Series A
issued by the American Tobacco Company 1901

The Taddy set of Admirals & Generals was issued in 1914 with different backs, some of which, including this one, are more difficult to obtain than others.

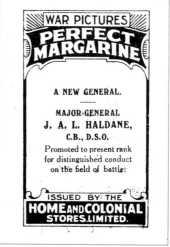

The Home & Colonial set of War Heroes consisted of 40 subjects and was issued by the Stores firm in 1916. It was one of three military sets that they issued at the same time and are all very attractive and interesting.

War Heroes
issued by Home, Colonial Stores Ltd.
1916

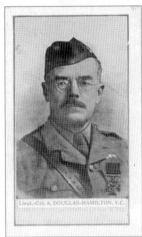

The Great War V.C. Heroes
issued by Gallaher Ltd.
1916

Lieutentant-Colonel A. F. Douglas-Hamilton V.C. is shown in this card from the Gallaher series of 200 Great War Victoria Cross Winners issued during the First World War. Although he spent most of his military career in the Queen's Own Cameron Highlanders, and was with that Regiment that he won his V.C., he served as Adjutant of the 6th battalion of the Gordon Highlanders from 1884-1899, before returning to the 2nd battalion of his old regiment.

Gallahers issued this series of cards between 1915 and 1918 in eight sets of 25, the first of which contained the winners during 1914 and in particular the retreat from Mons in which a number were awarded. In fact Gallaher produced a number of well researched and interesting military series, many examples of which are shown elsewhere in this book.

The next two examples are from the set of 43 British Army Boxers which were issued by W.D. & H.O. Wills to British Garrisons overseas under the Scissors brand of cigarettes, one of 15 sets of military cards issued under the brand name, although a few of them were also included with other brand names. In addition some were reproduced by the British American Tobacco Company, which as had already been mentioned, was jointly owned by Imperial Tobacco Ltd. and the American Tobacco Company.

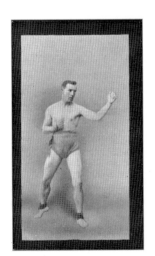
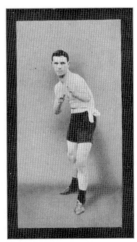

British Army Boxers Series
issued by W.D. & H.O. Wills Overseas (Scissors)
1913

The left illustration is of Private H. Donnelly of the 2nd battalion who was the winner of the Lightweight competition at Cawnpur. He weighed 9st. 9lbs. and was 5ft. 6ins. in height.

The one on the right is Private G. Adams also of the 2nd battalion. He beat Drummer Osborne of the Royal Welsh Fusiliers, the Featherweight champion of India, in three rounds at Amballa in 1911. He was 5ft. 6ins in height and weighed 9st.

AUTHOR

David Hunter was born in Glasgow in 1942 and educated at Daniel Stewart's Collage, Edinburgh. After a period in catering management he joined the army in 1964 and served in the Intelligence Corps, being attached to Headquarters 48 Gurkha Infantry Brigade Group for most of his service. This was followed by spells in Headquarters British Army on the Rhine and the Recruitment Section in the Intelligence Corps Depot.

After having left the army in 1970 he joined the Sales Force of the cigarette manufacturer John Player & Sons, based in Nottingham. He worked in the North East, Yorkshire, Wales and South Warwickshire, before leaving the Sales Force and transferring to the Employee Relations Department in Nottingham, where he held a number of different managerial positions.

After having left John Player & Sons in 1988, he was appointed Group Personnel Manager of the Nottingham based Library Services, a Blackwell Company, with responsibility for all personnel matters at the three locations. He was also a member of the Blackwells Board of Pension Fund Trustees .

He took early retirement three years ago and runs a small part-time business buying and selling cigarette cards. He also runs his own fairs and auctions four times a year at the Silverdale Community Centre, near Clifton Bridge, Nottingham.

A keen collector of military cigarette cards and post cards, he is married with one daughter at university. He is an active member of the Military Historical Society, being its Honorary Secretary for a short while, and a magistrate on the Nottingham Bench.

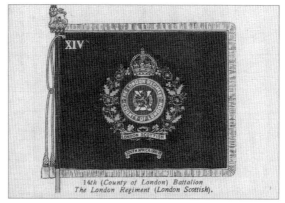

Regimental Colours (Silk)
issued by B. Morris & Sons 1916